# SQUARISMS

A

Digital

Art

Project

# De McClung

Copyright © 2017 by D. L. De McClung

All rights reserved.

ISBN: 1548900664
ISBN-13: 978-1548900663

<O>

**Re'el De'el Books**
**McClung Originals**
**Eye Demon Studios**
**D'eldeli Los Festus on Teverbaugh**
**Worthington WV 26591**
**America**

# DEDICATION

To
Those
Who
Can
See
In
The
Box
From
Outside
The
Box

And

Lilo

# INTRODUCTION

Squarisms is a Work of Art that explores the possibilities of visual expression using the square as the primary form. Each piece, of course, stands alone and on its own merit, however, the entirety of this book represents one Work of Art. Thus, U*niplexity*. One *of* many parts. This *Work of Art* utilizes hard-edge expressionism and minimalism. As a Rule, I don't explain the Art that I make, because the Art **is** the explanation! **Look** with your eyes, **See** with your mind! Titles are provided at the end of the book, not as an explanation, but as a clue.

< **O** >

Prints of the Artworks in this collection can be purchased individually or collectively as a set. Prints come in an assortment of sizes. Prices provided upon request.

Select works from this collection are also available on FineArtAmerica.com, or the Artist's Fine Art America webpage: de-mcclung.pixels.com

Please visit the official website of the Artist, D. L. De McClung at: www.deldemcclung.com

Other Books by D. L. De McClung

WORDS IN A ROW: BOOK ONE [The Early Poems]

NIPS
[A celebration of the human nipple]

COLORS

FLOWERS DE'ART

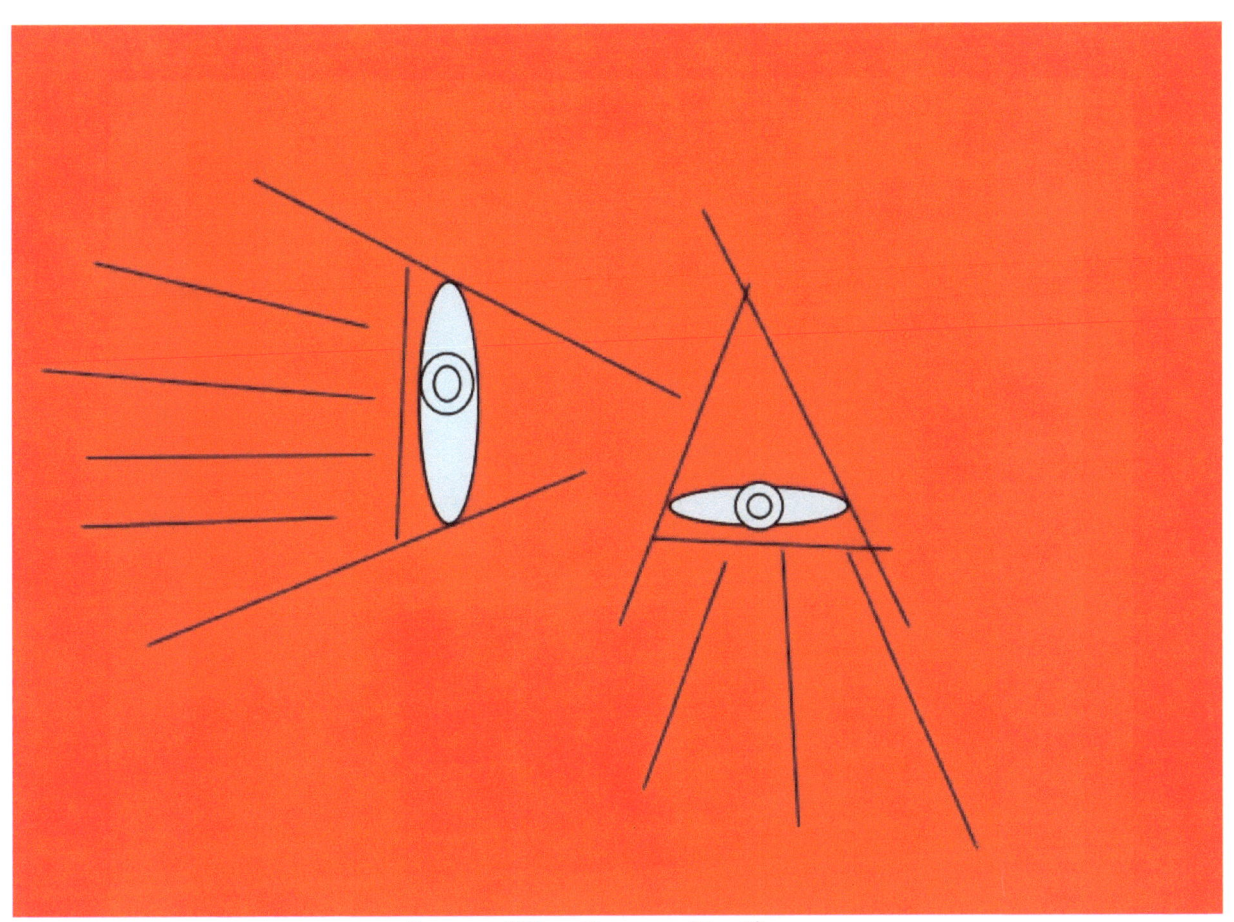

**Logo of Eye Demon Studios**

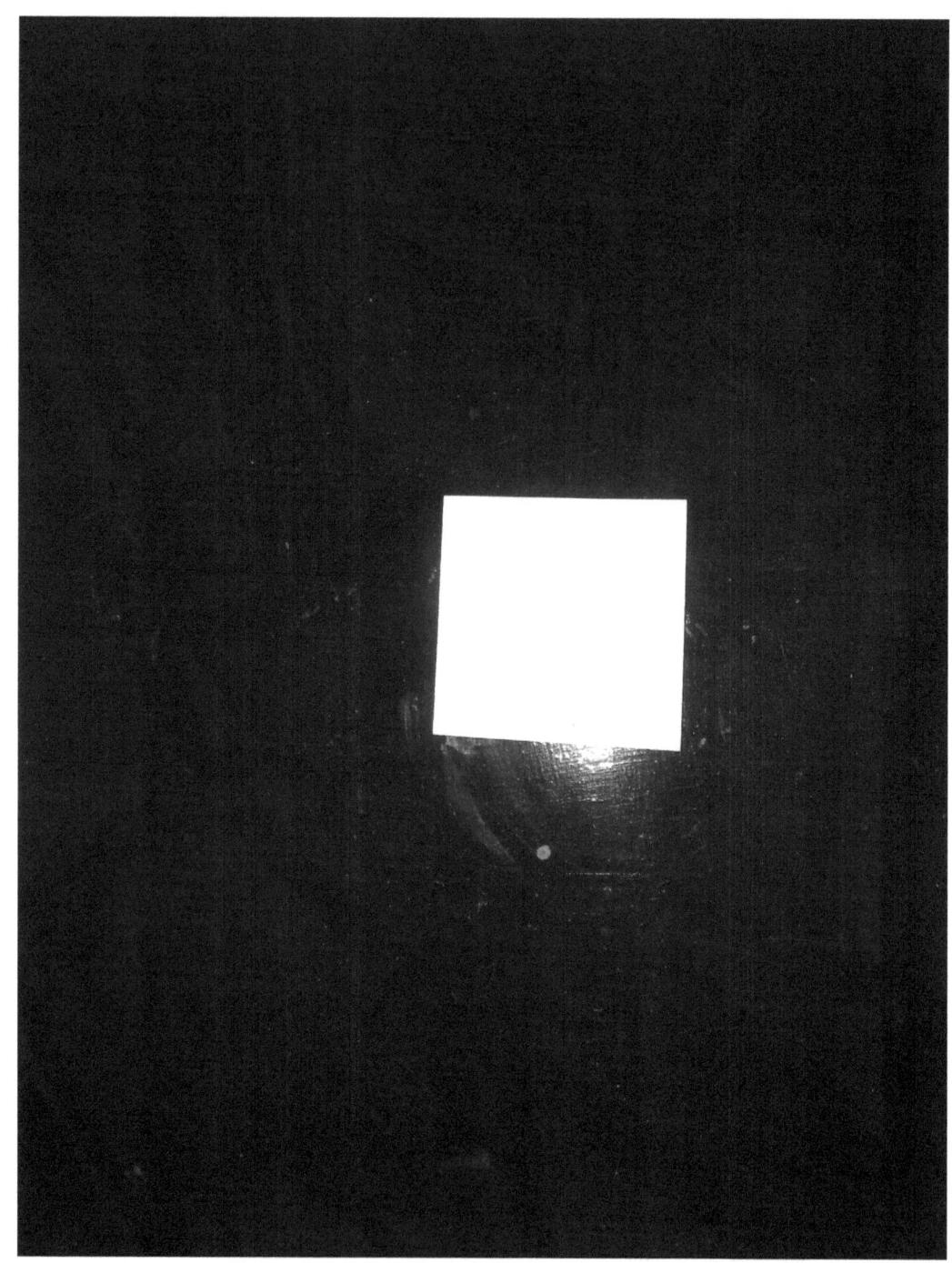

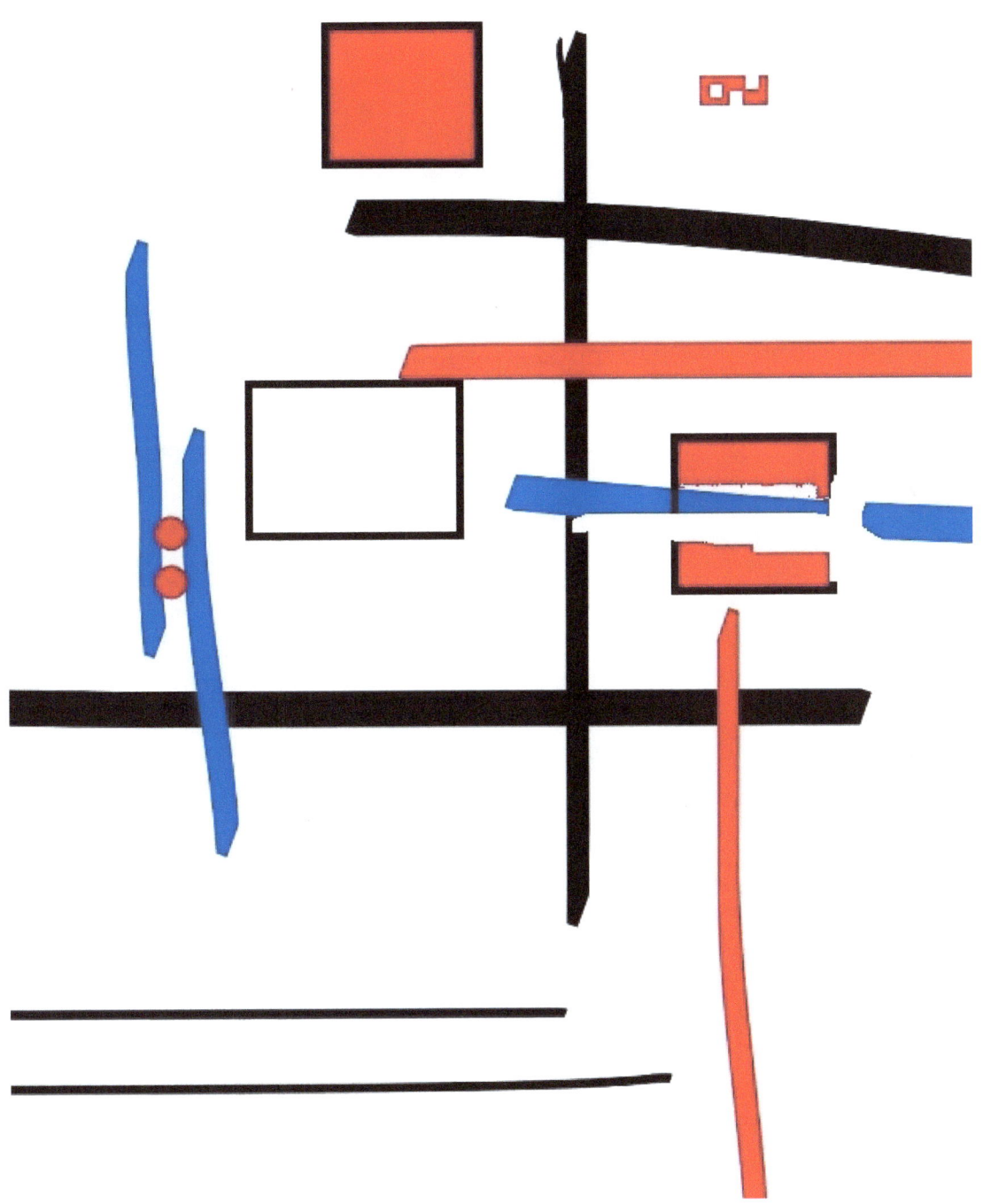

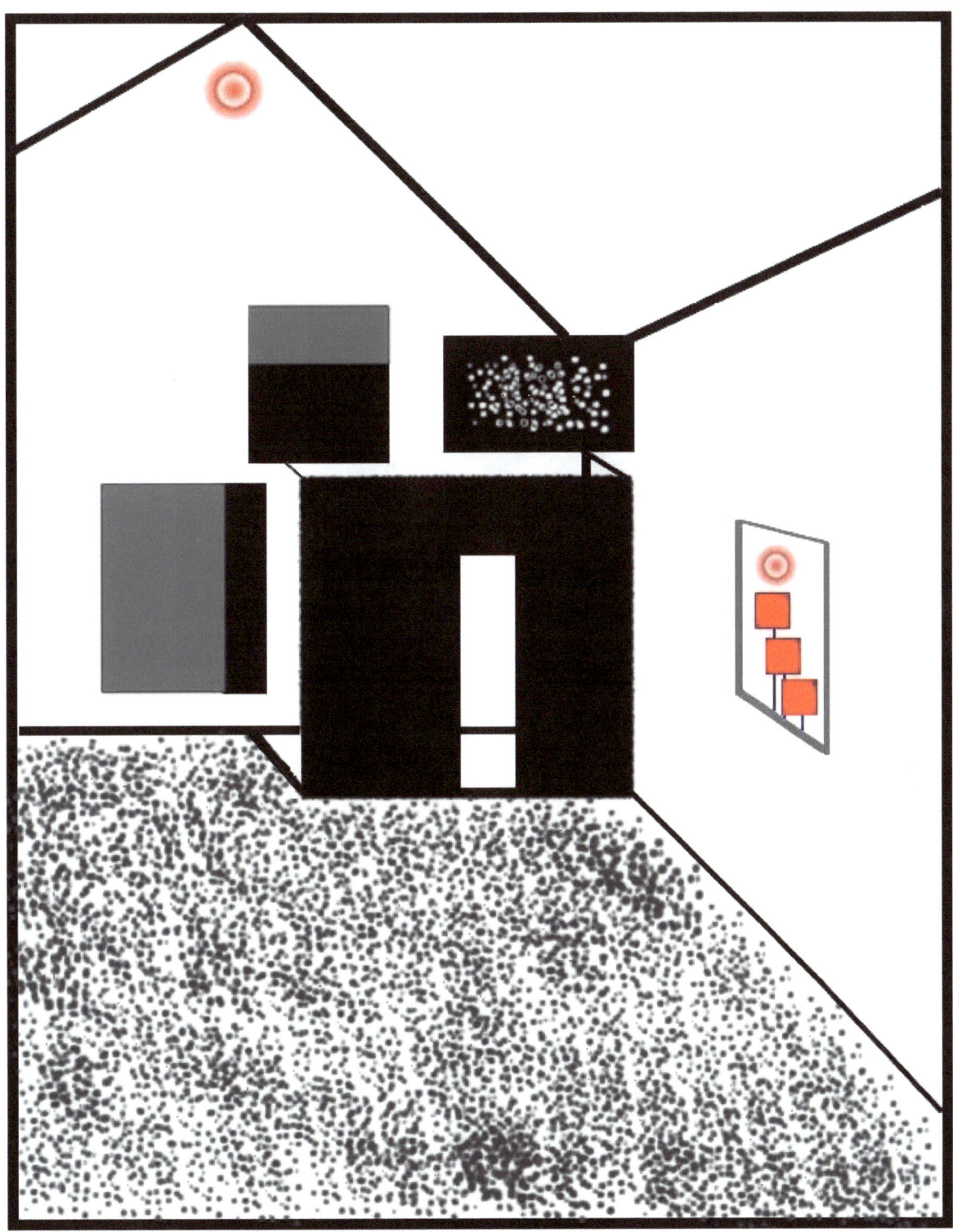

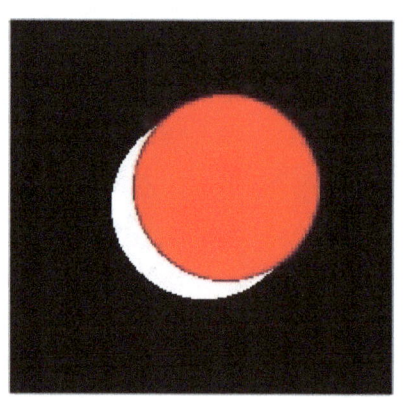

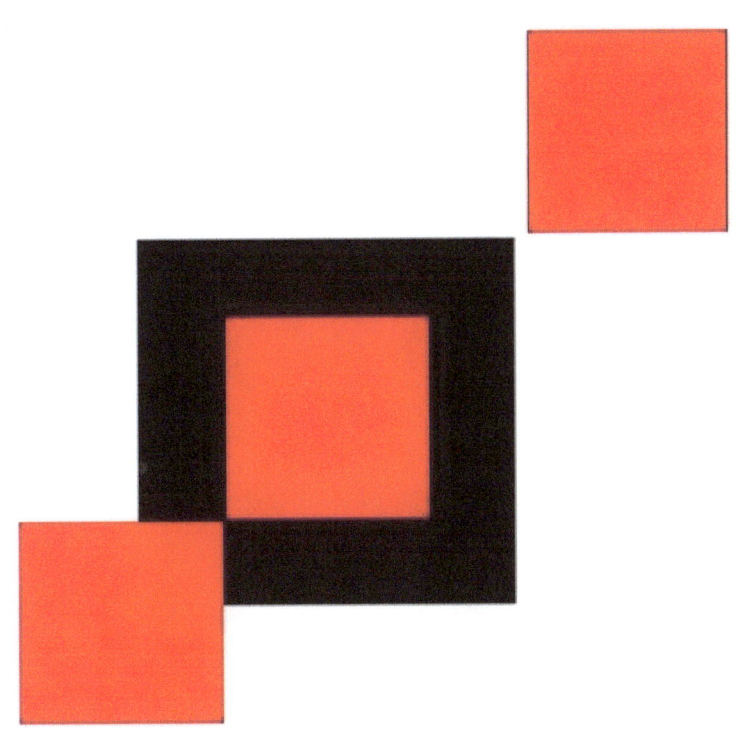

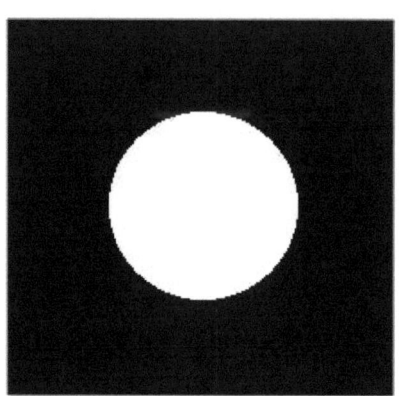

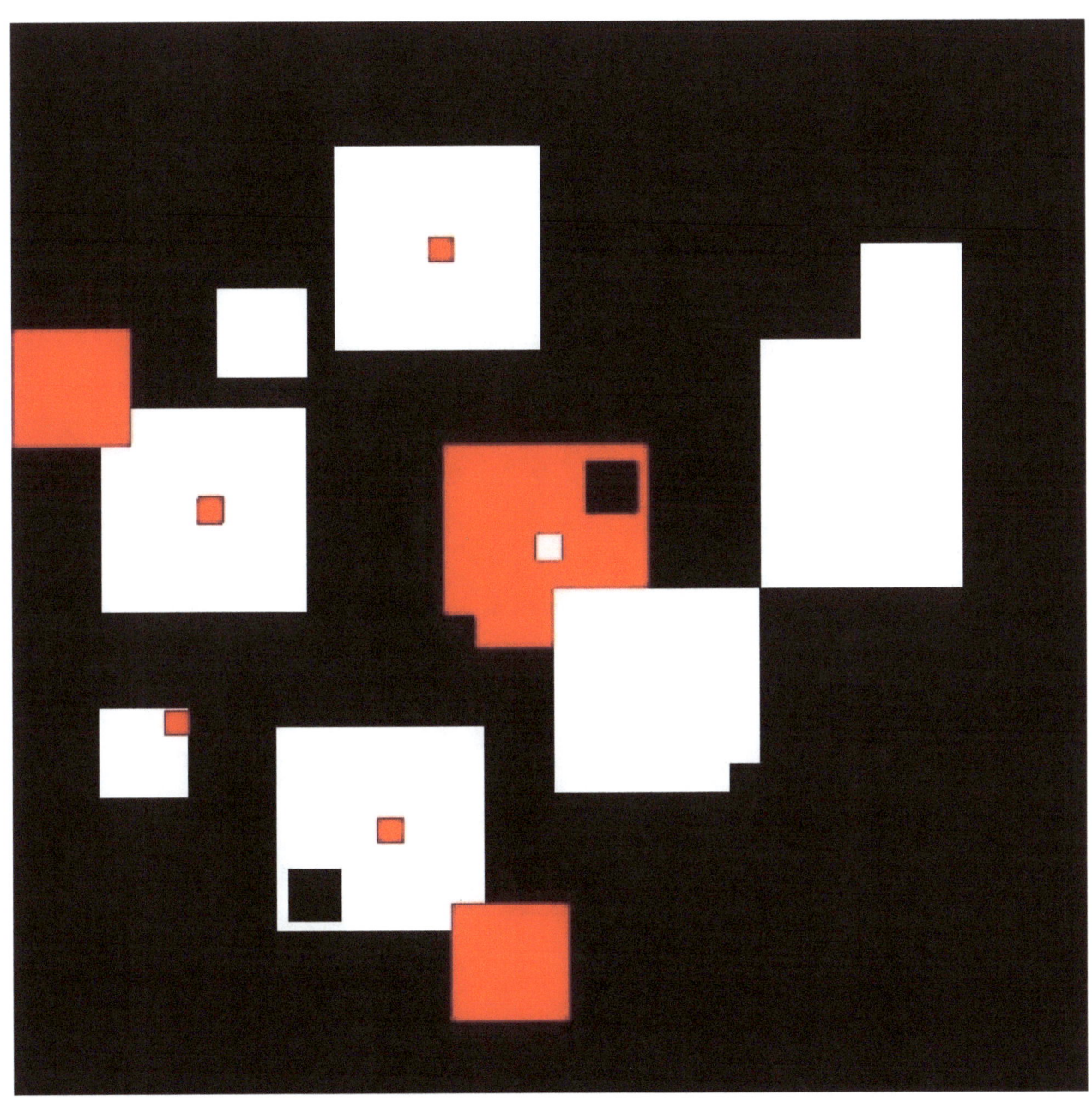

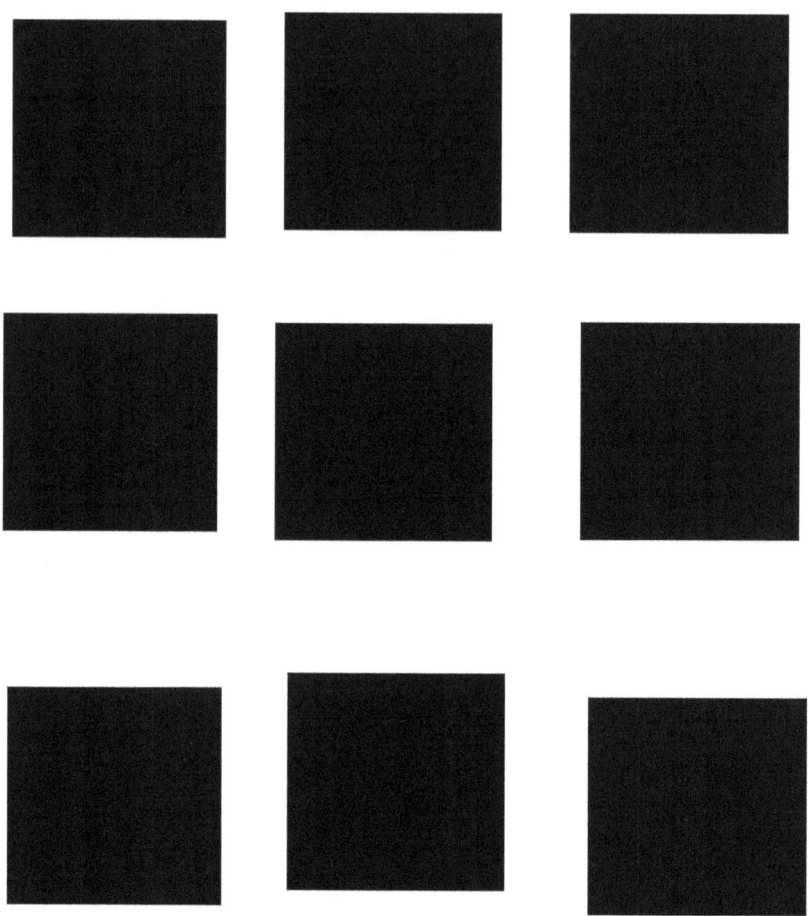

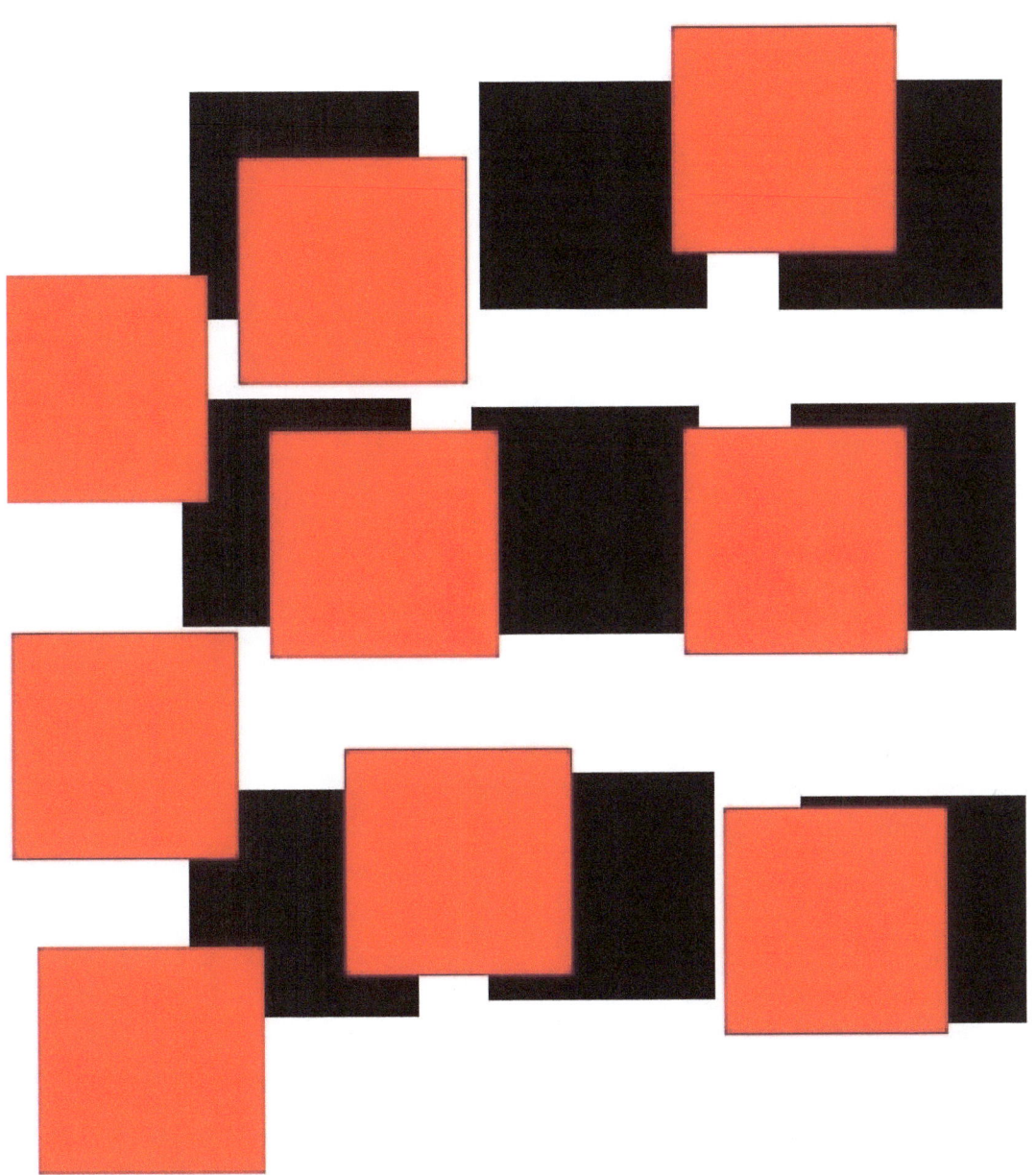

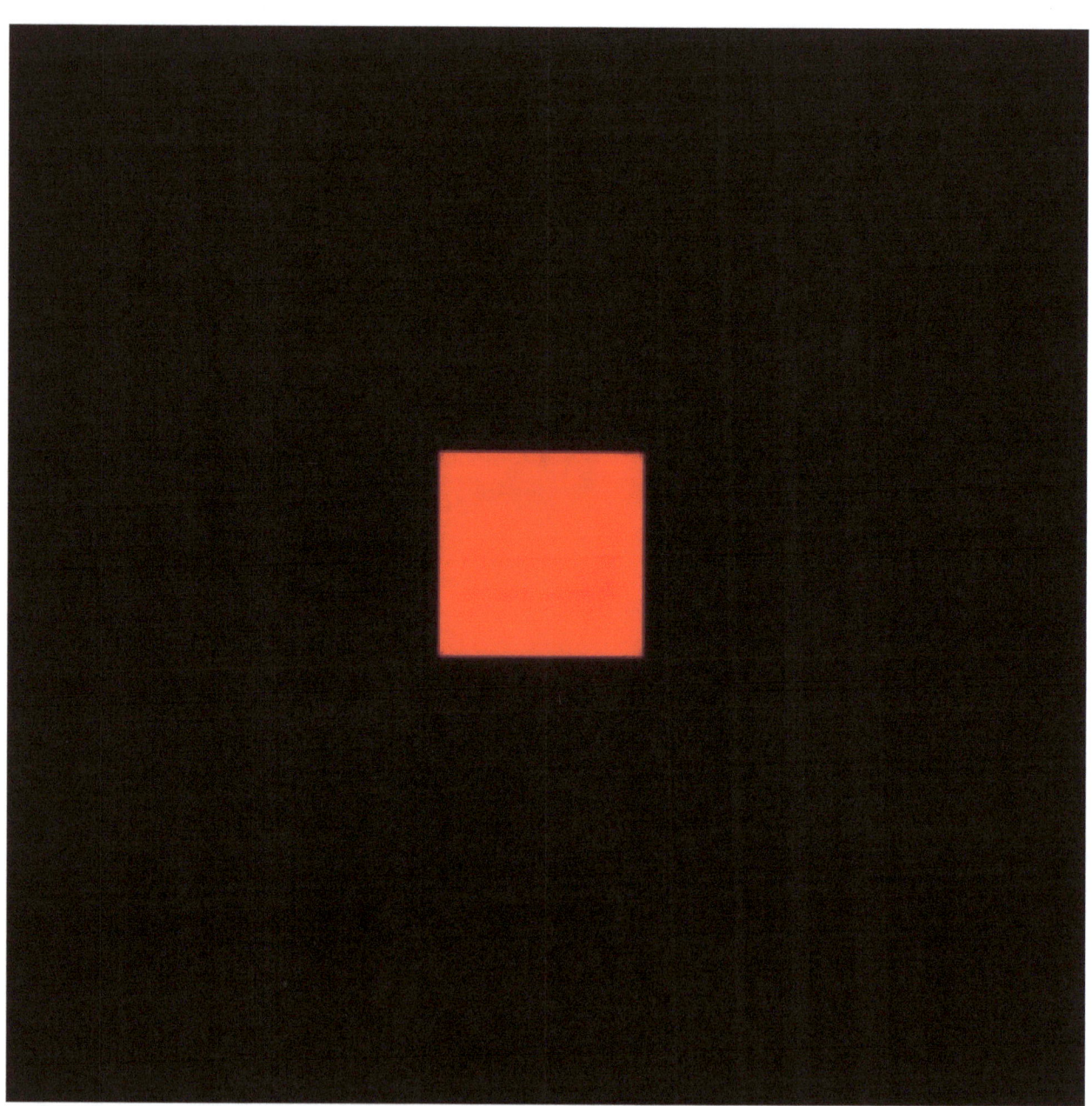

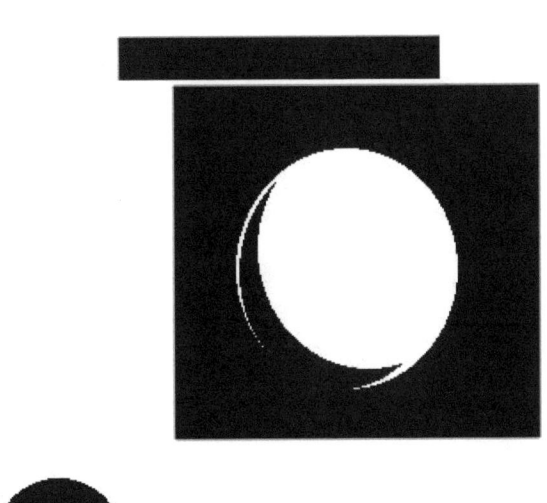

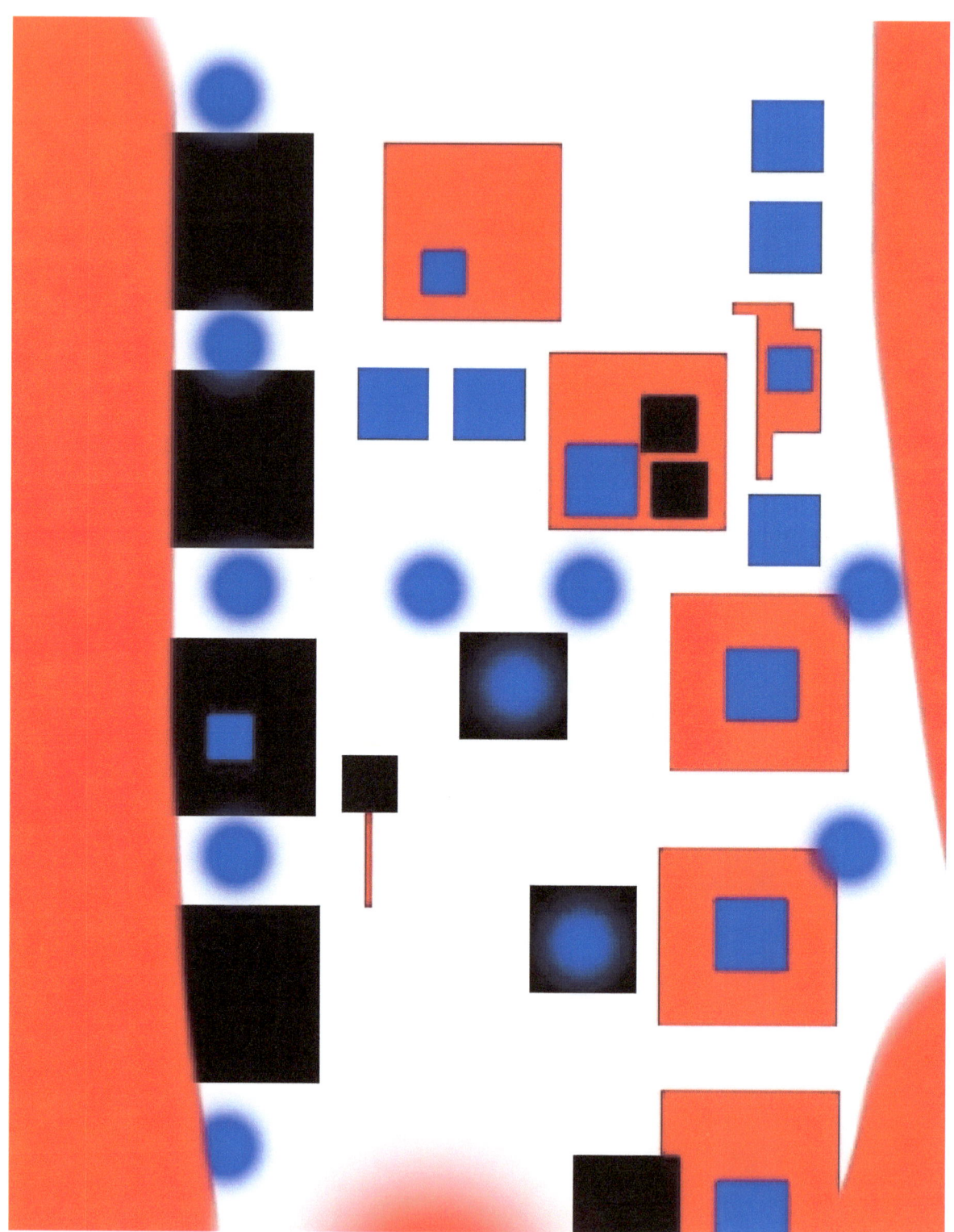

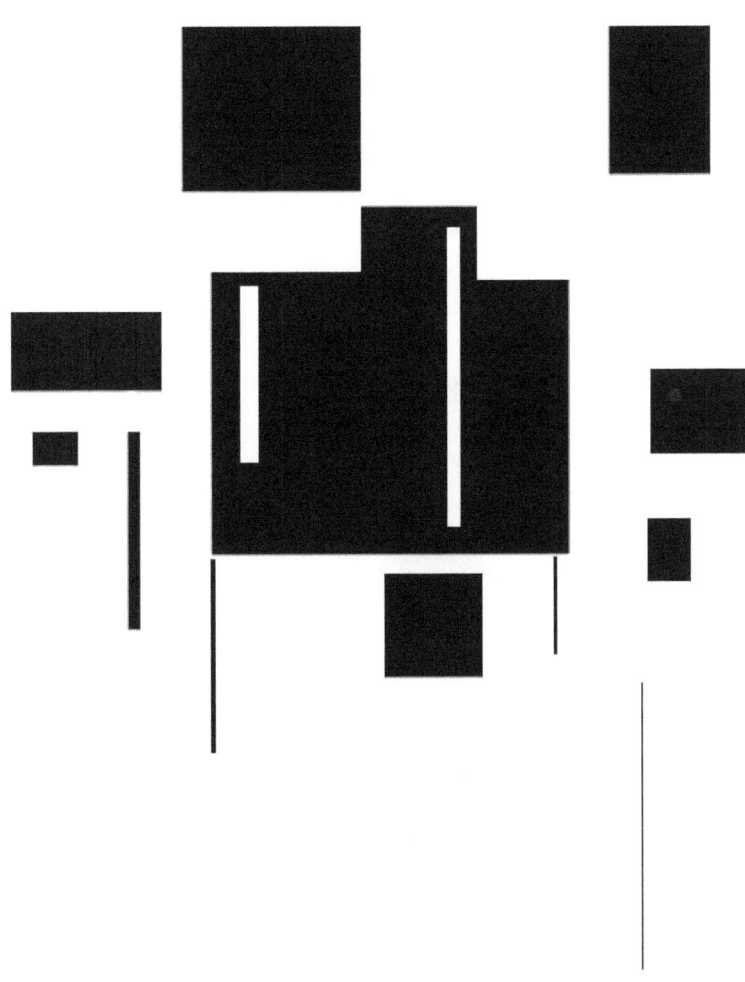

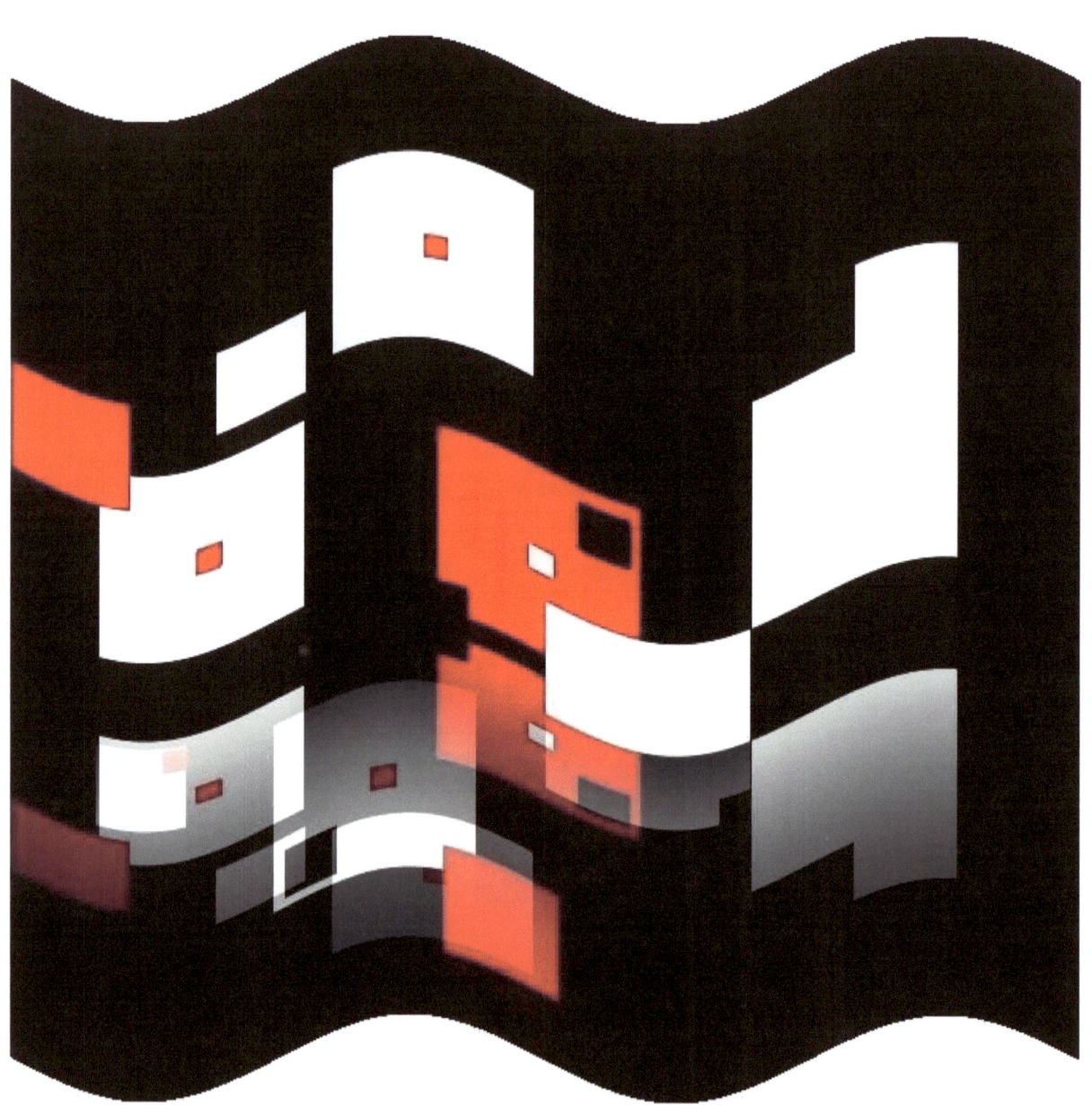

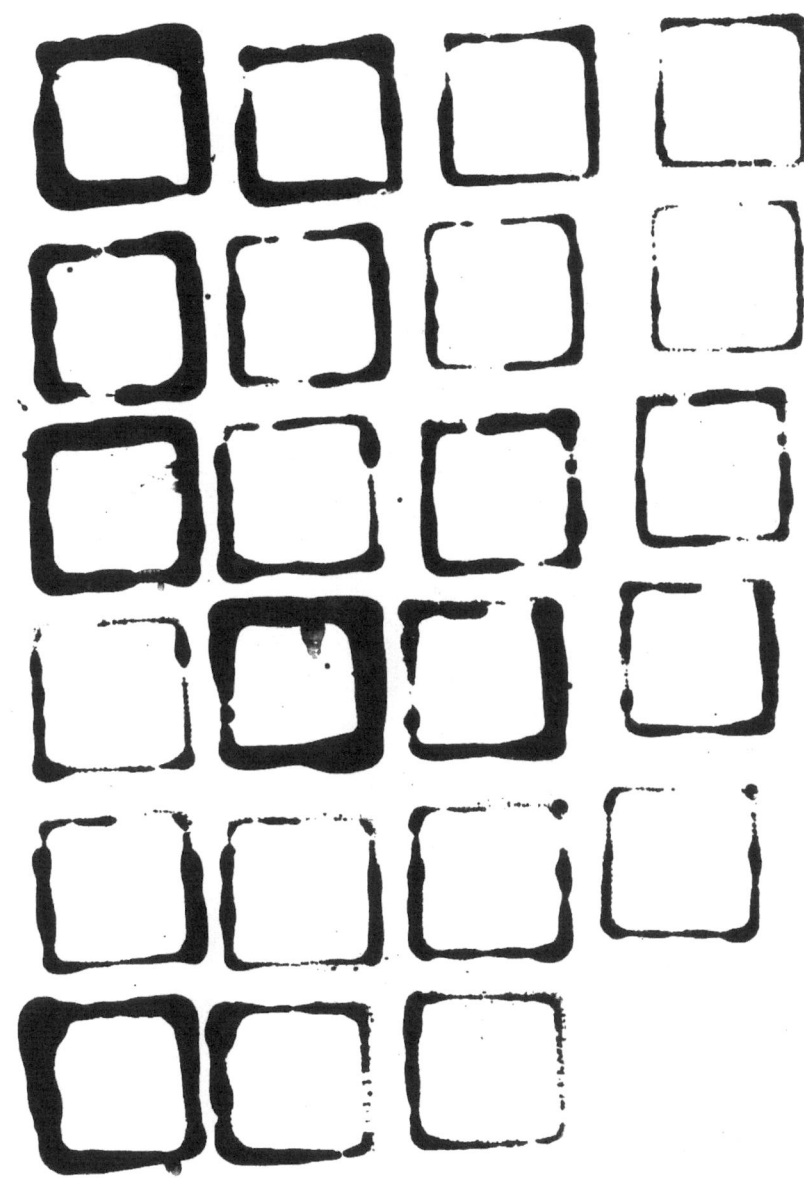

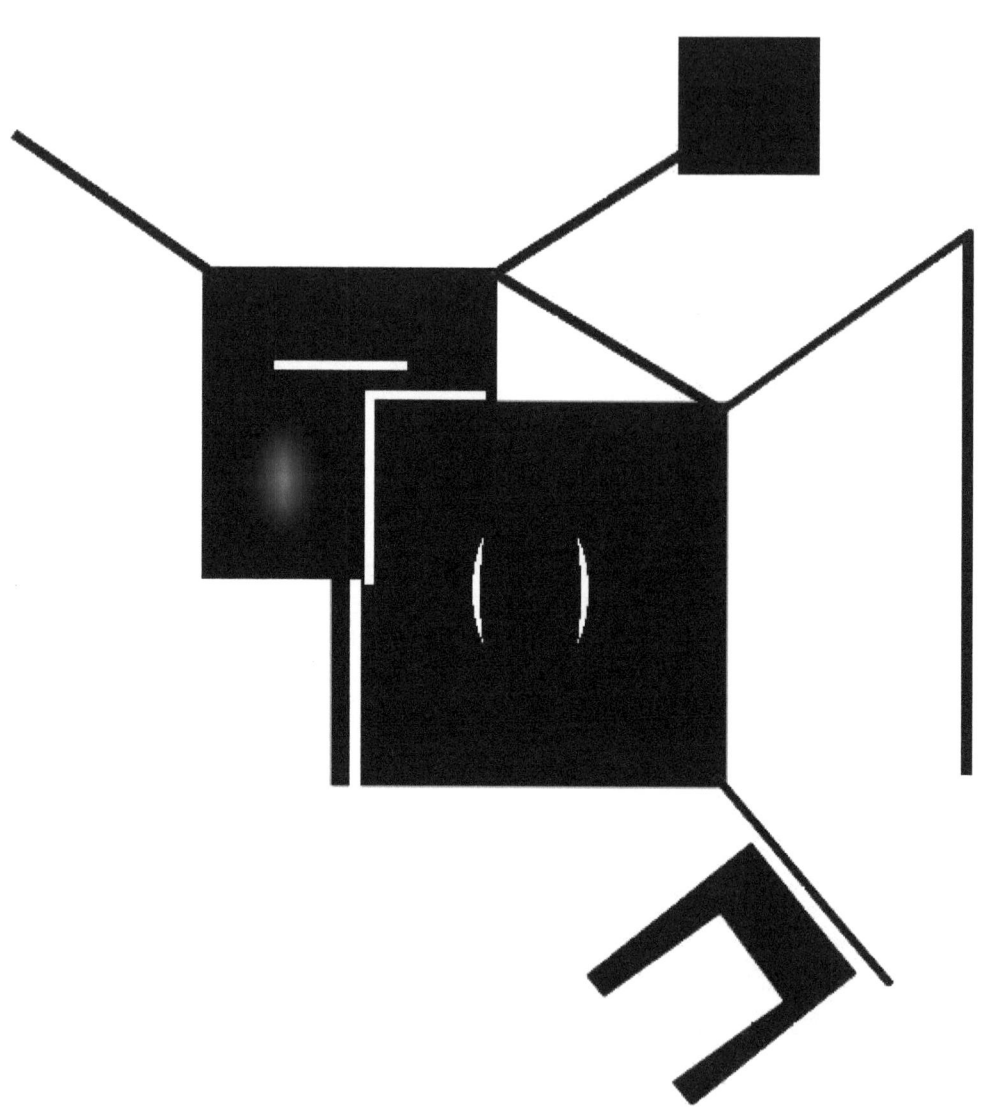

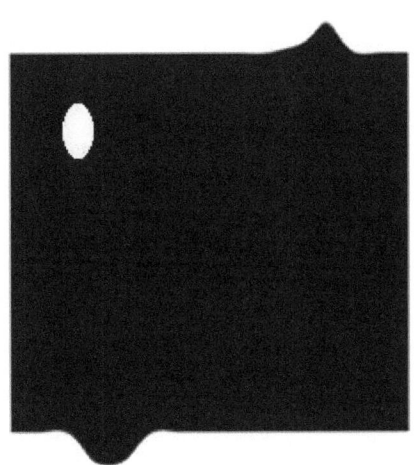

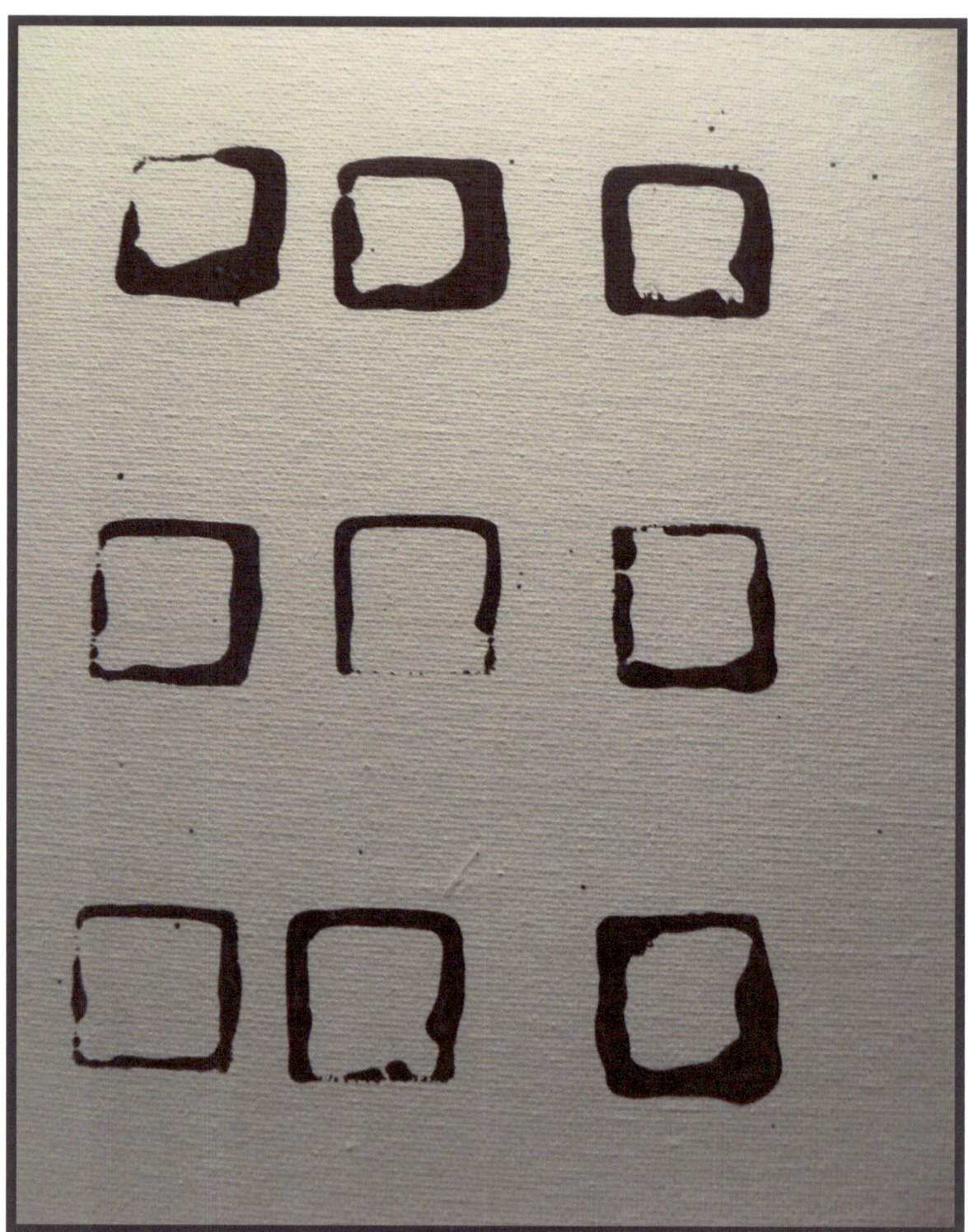

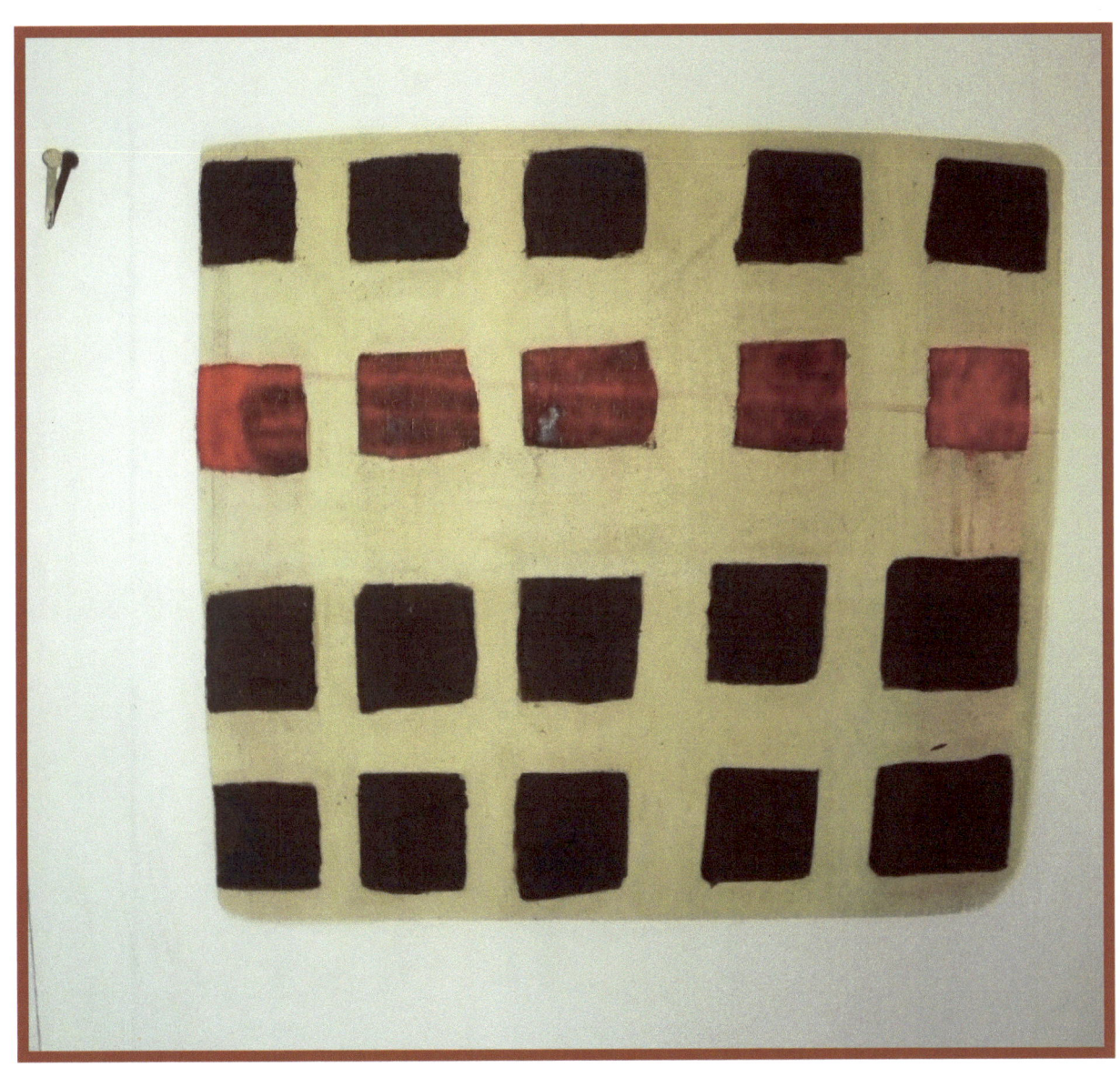

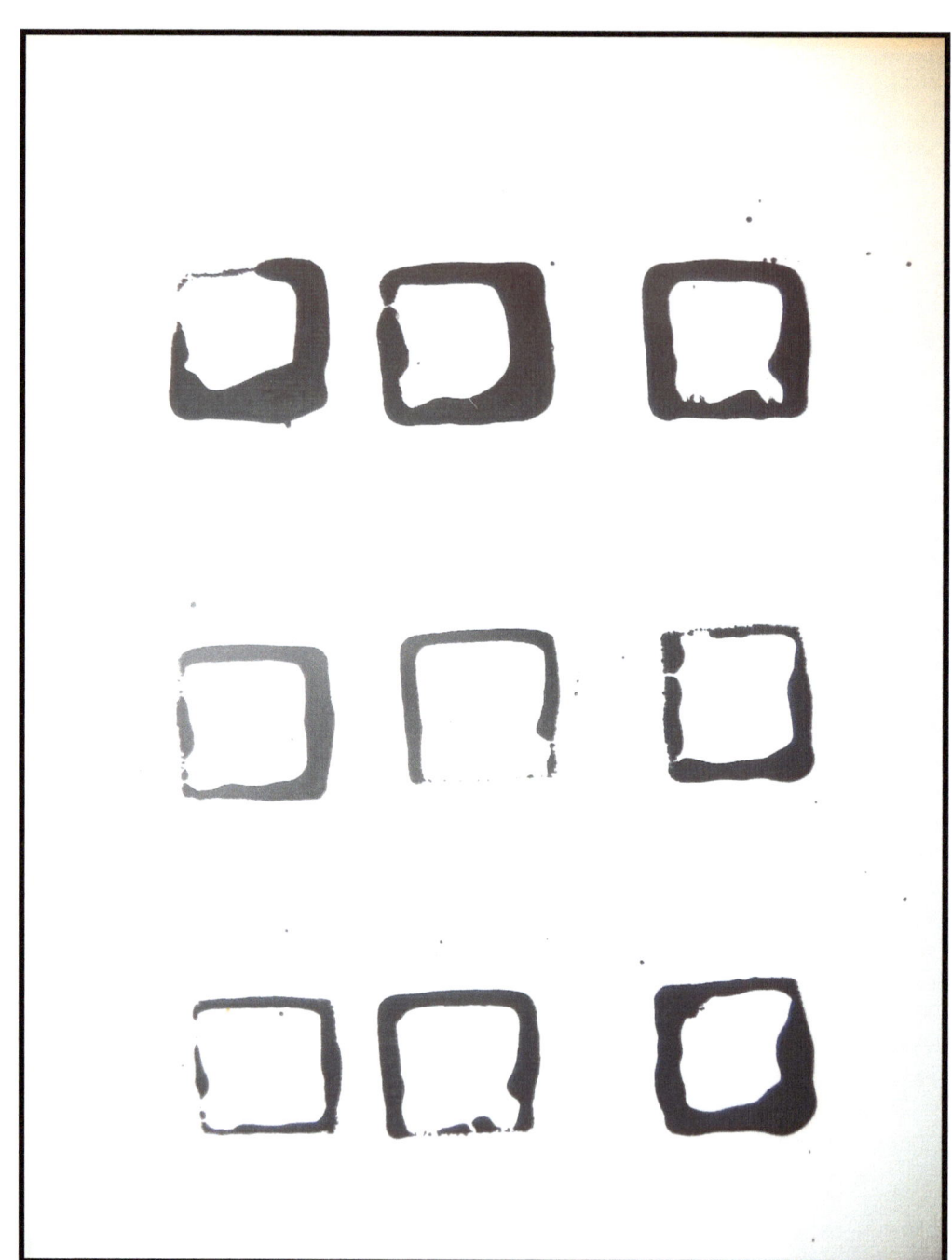

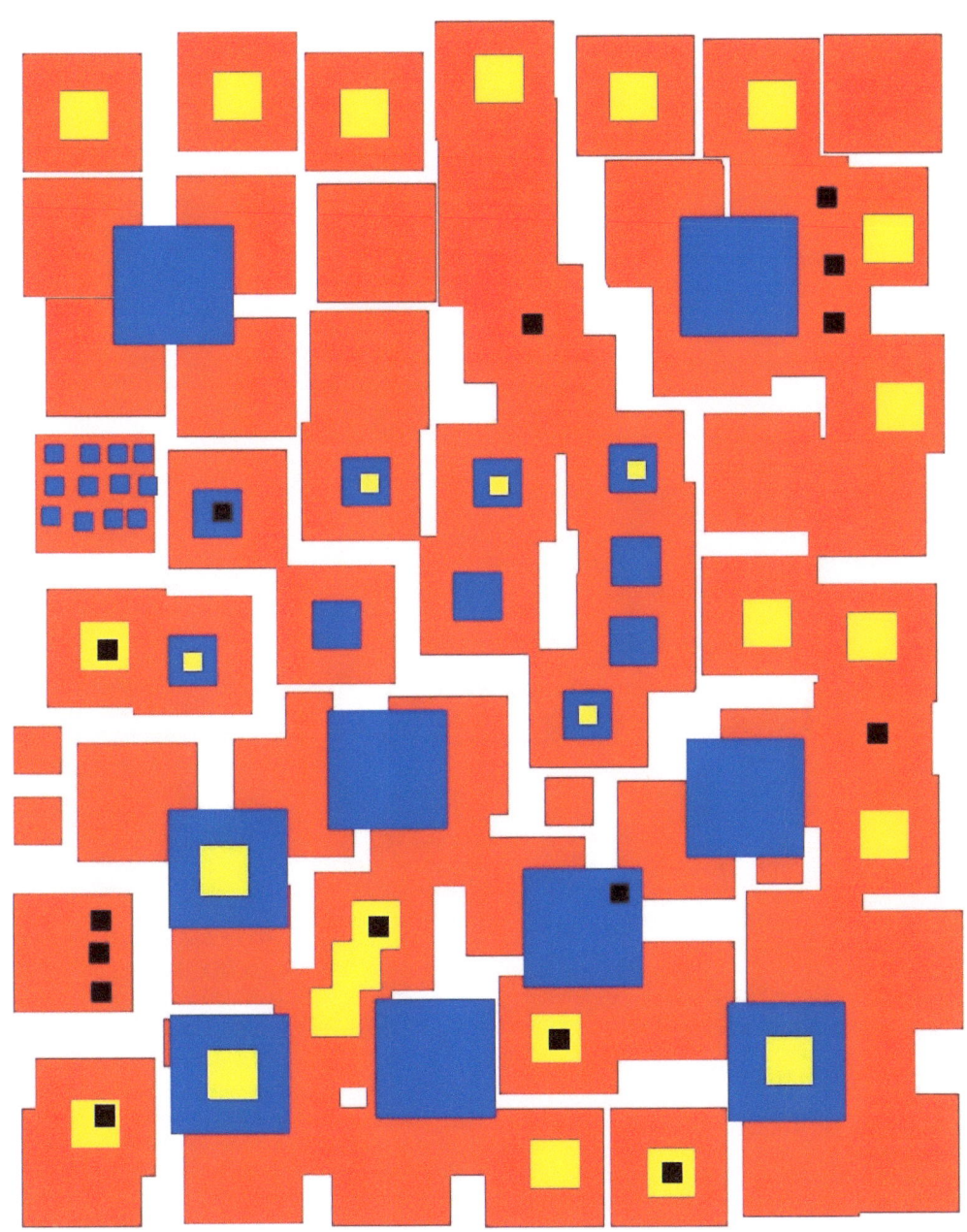

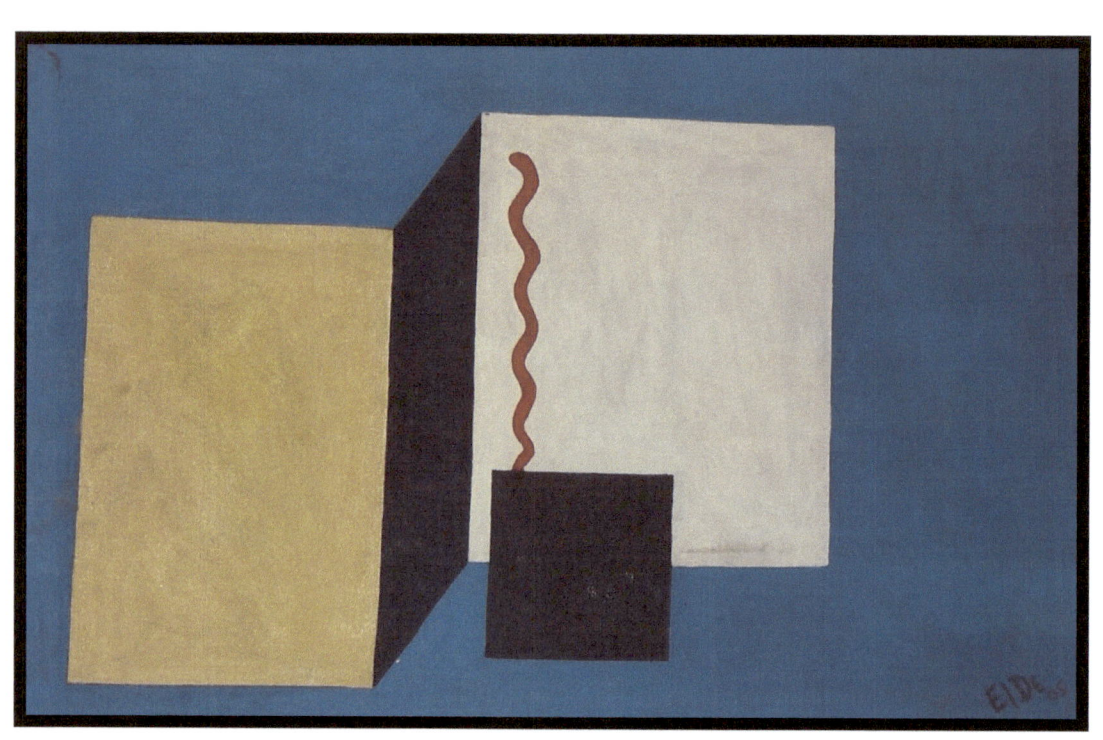

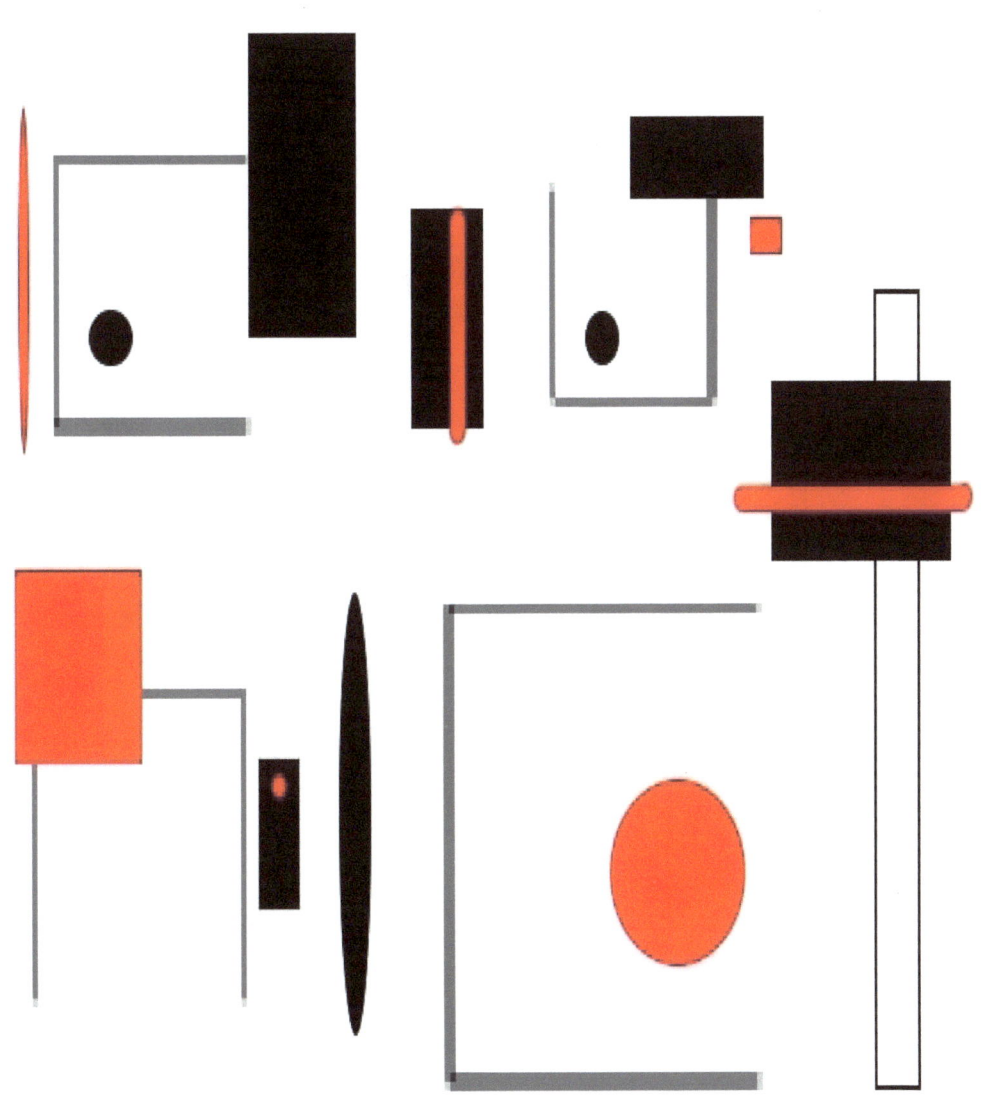

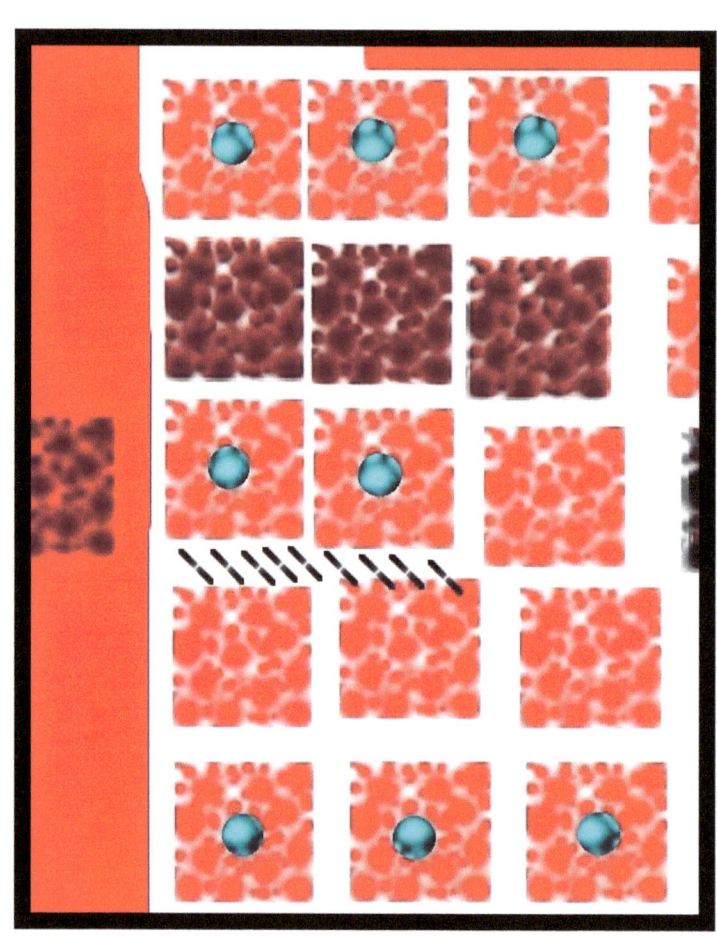

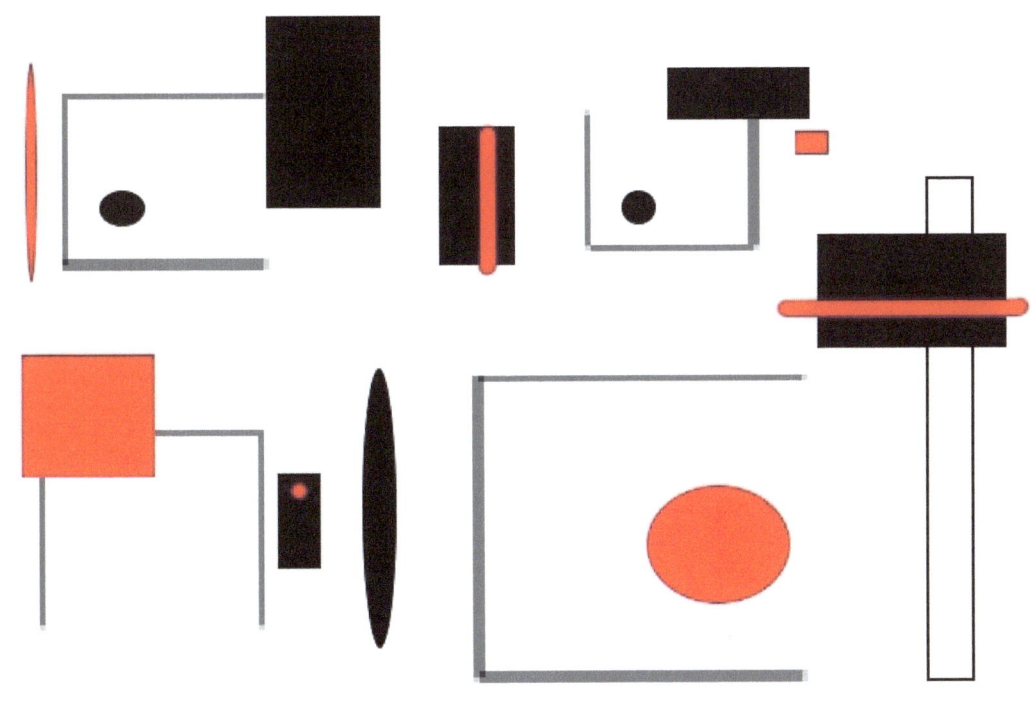

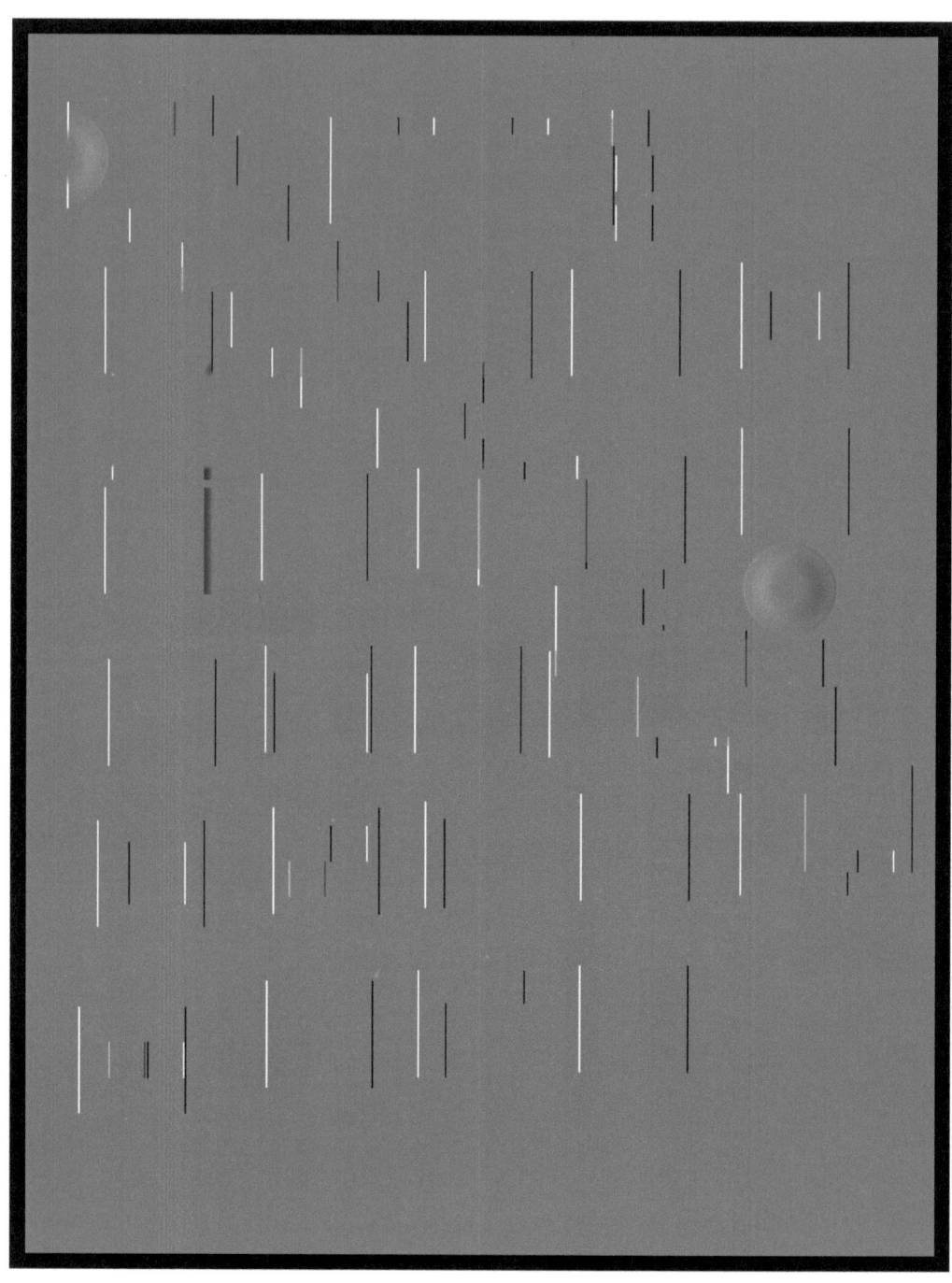

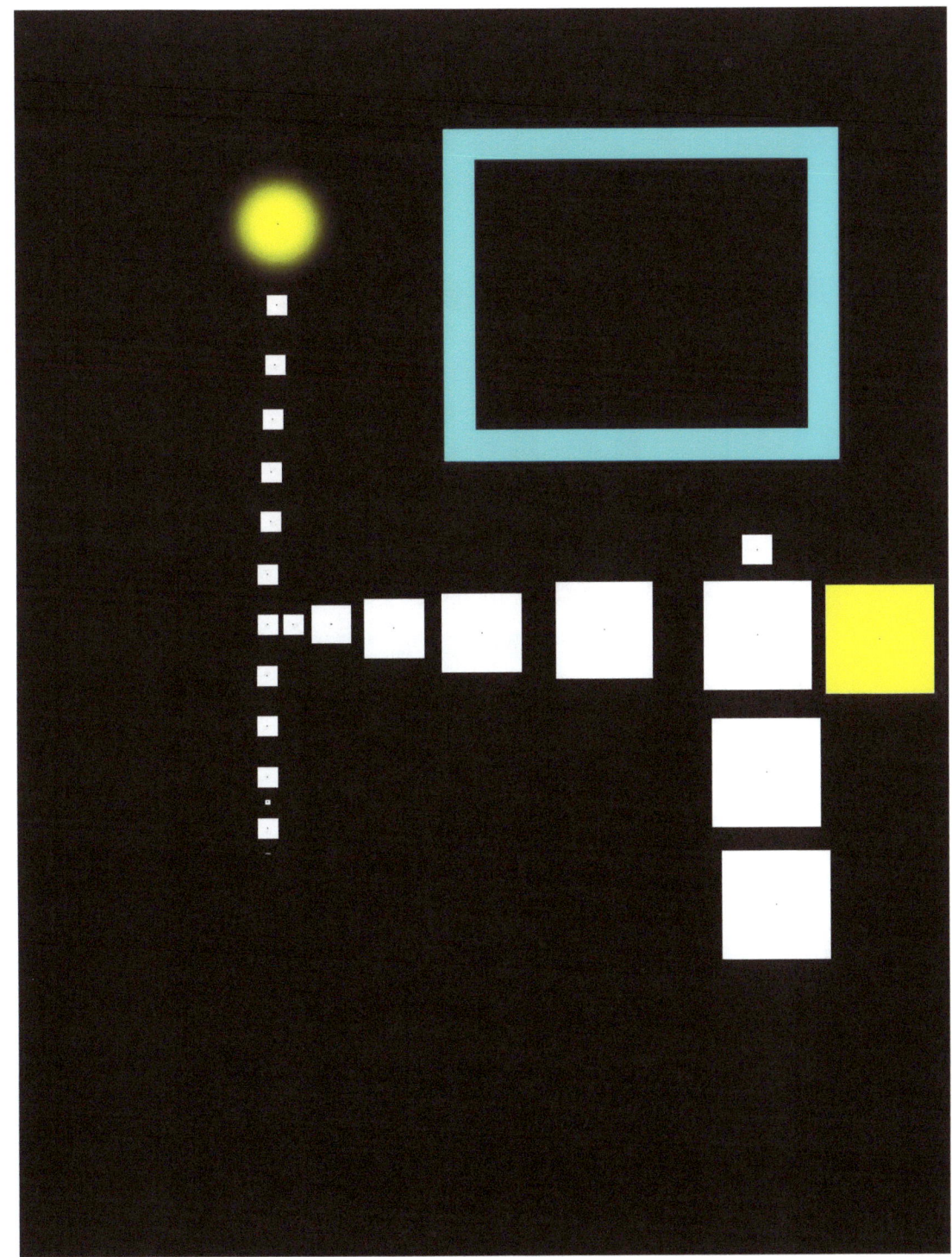

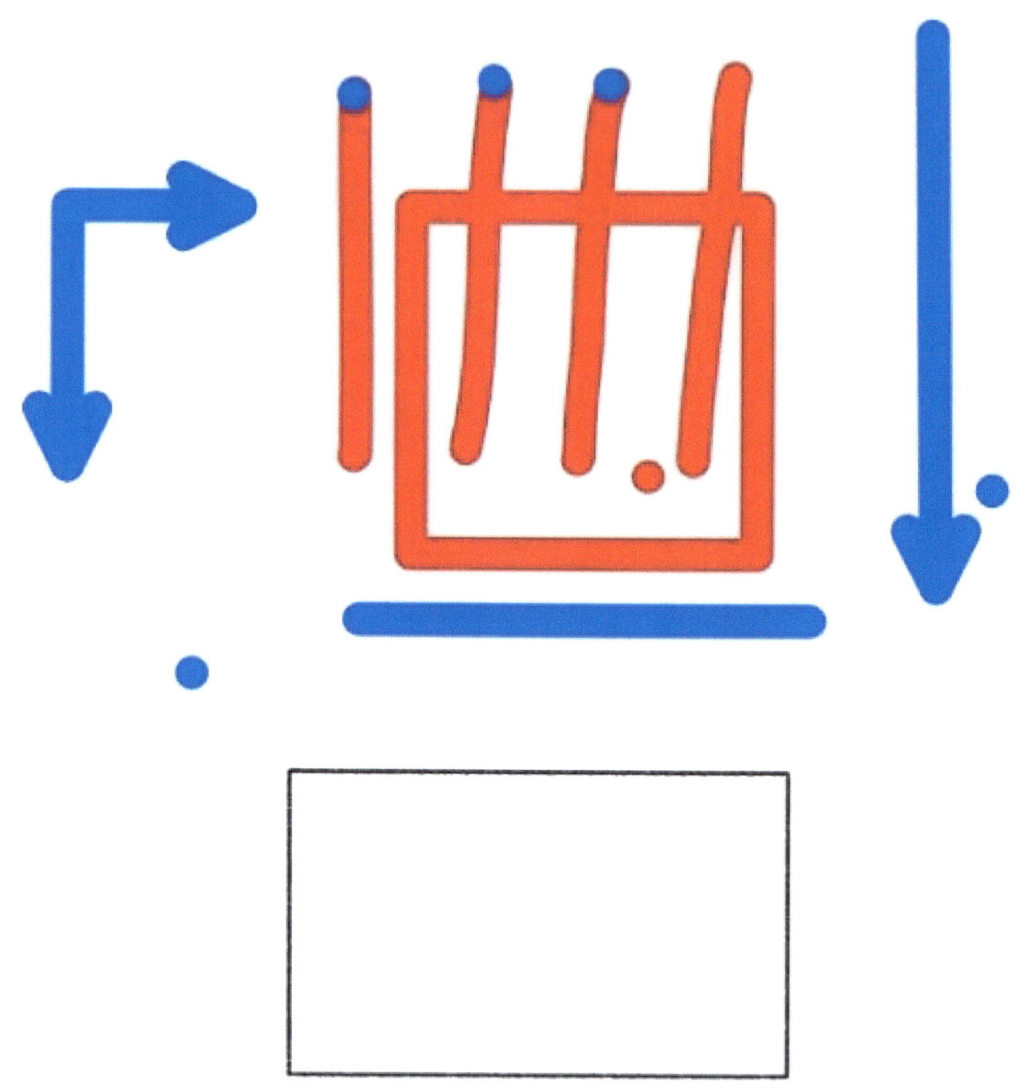

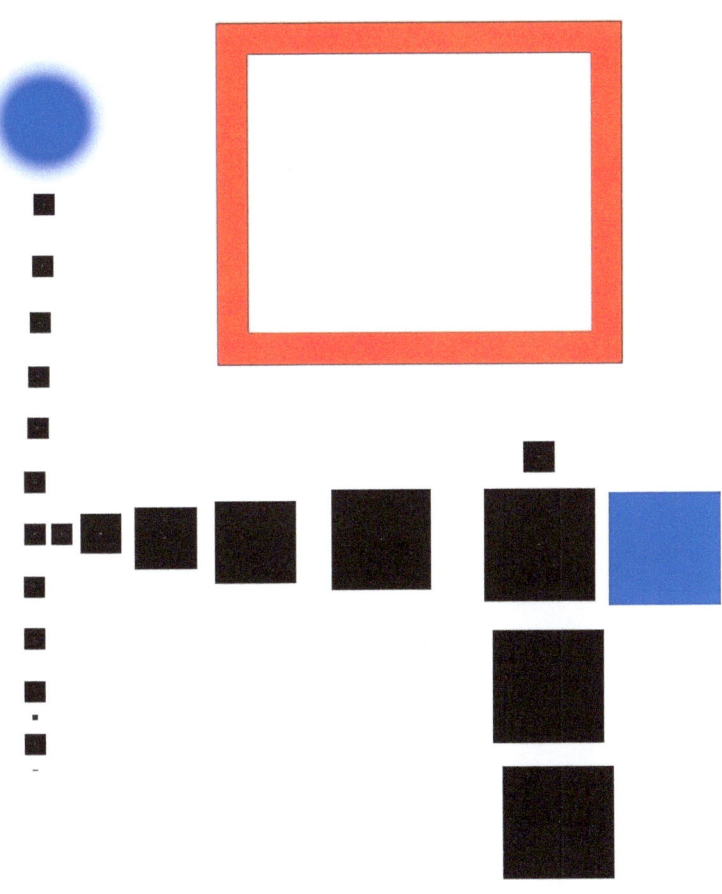

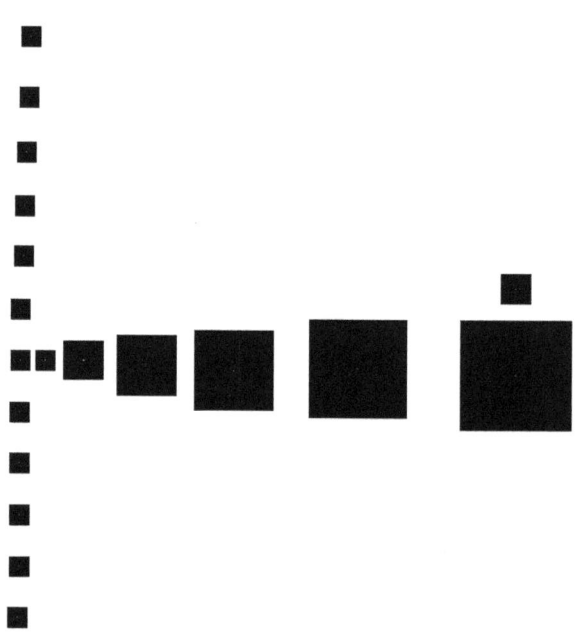

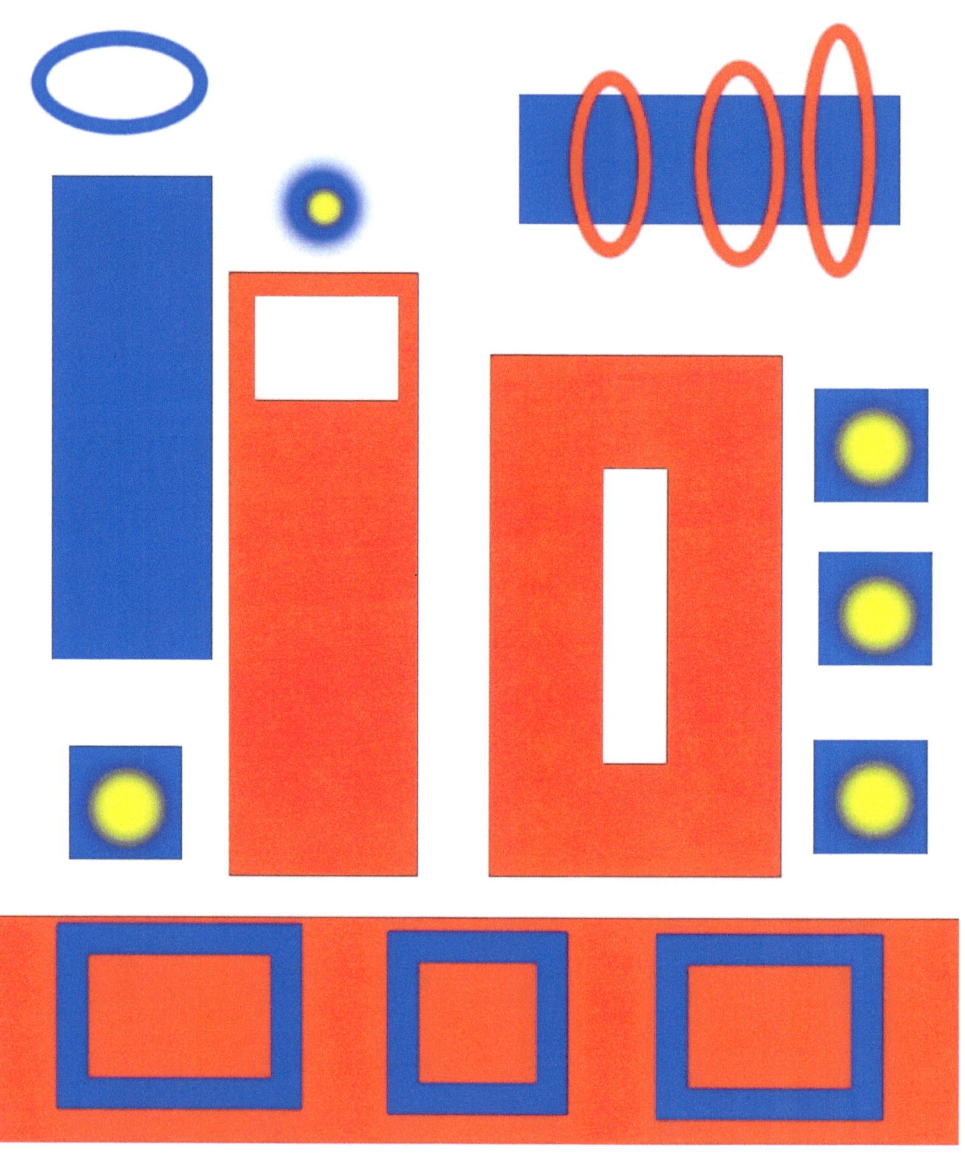

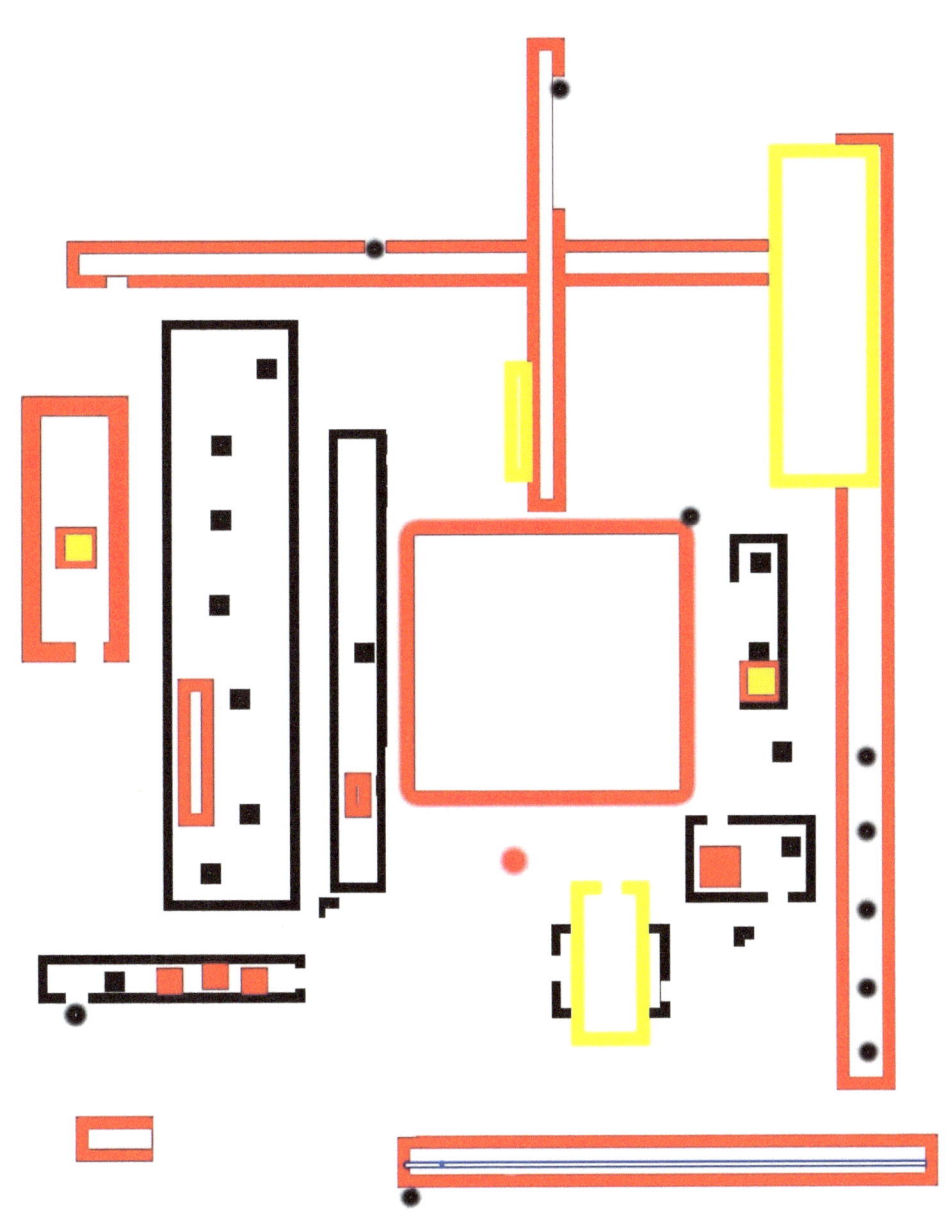

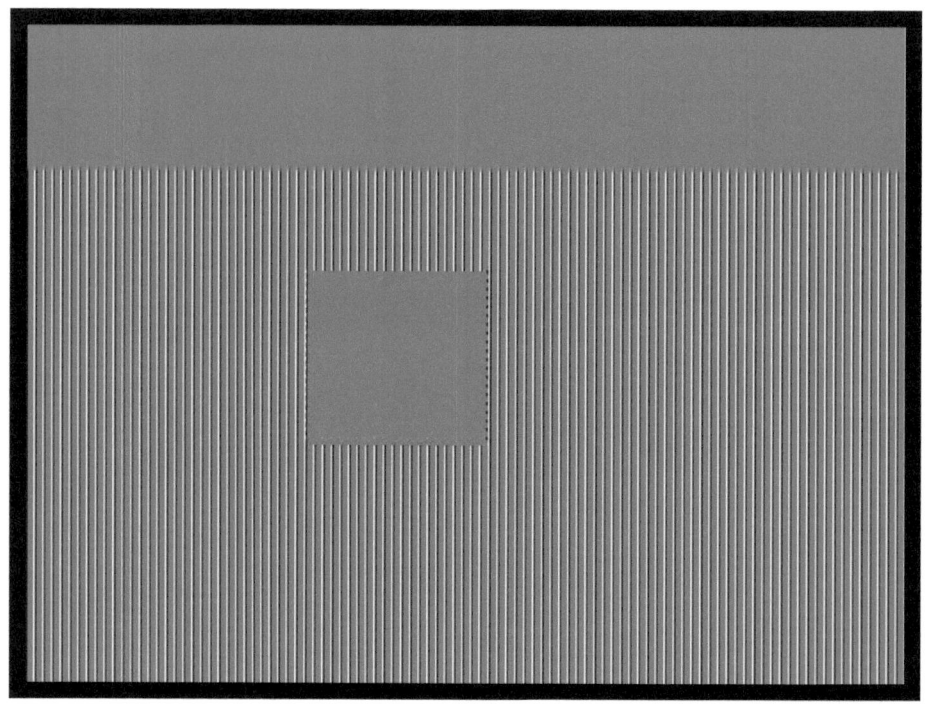

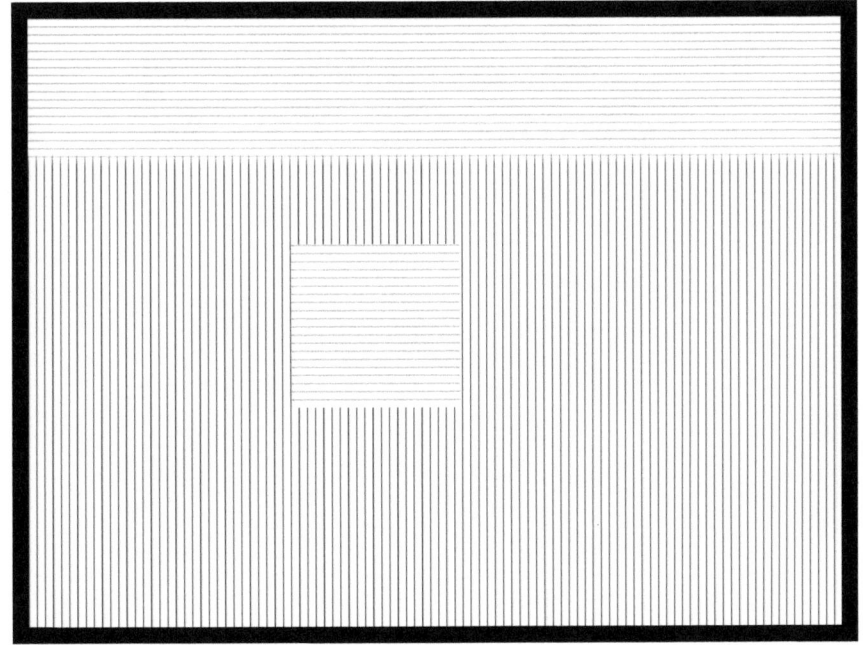

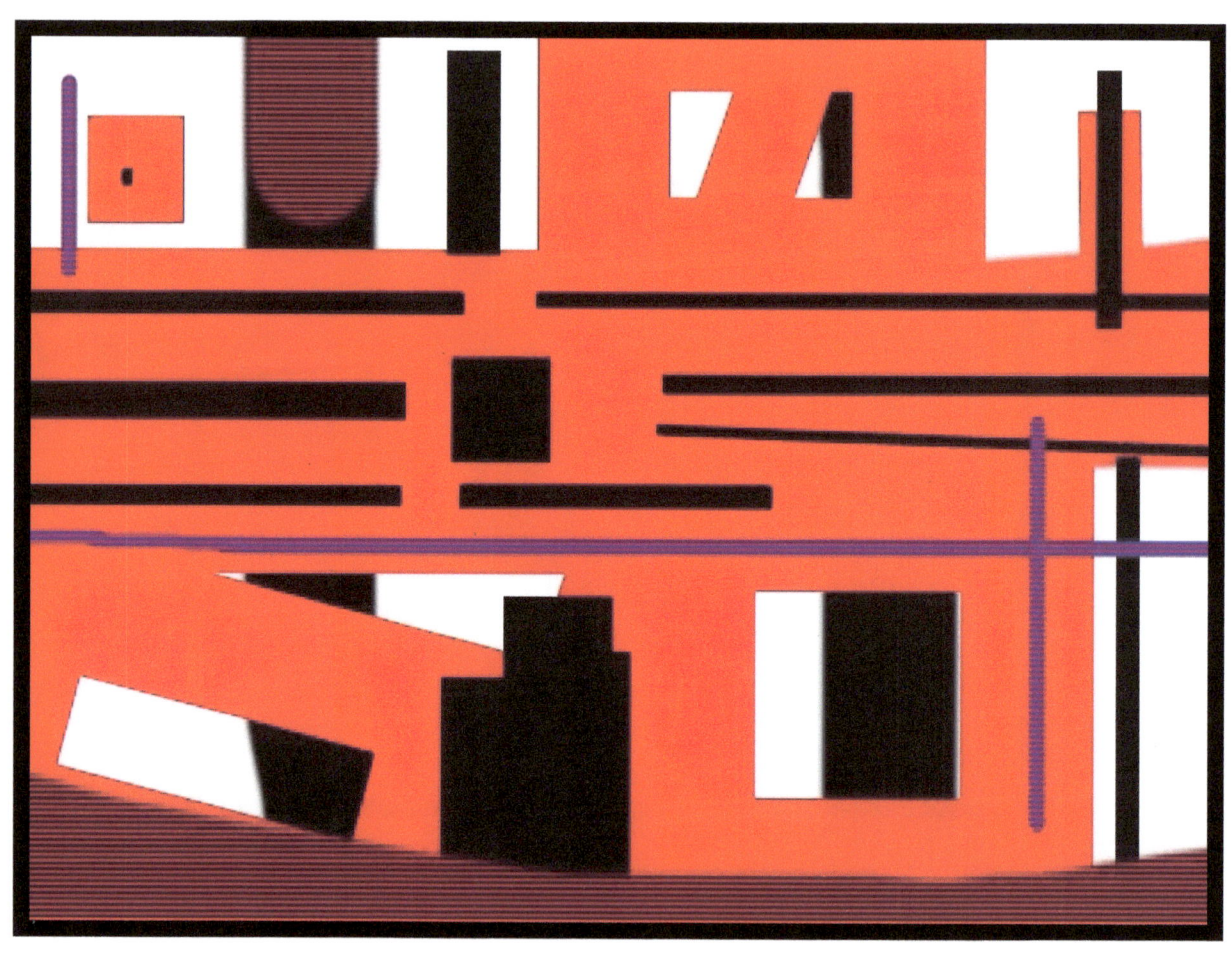

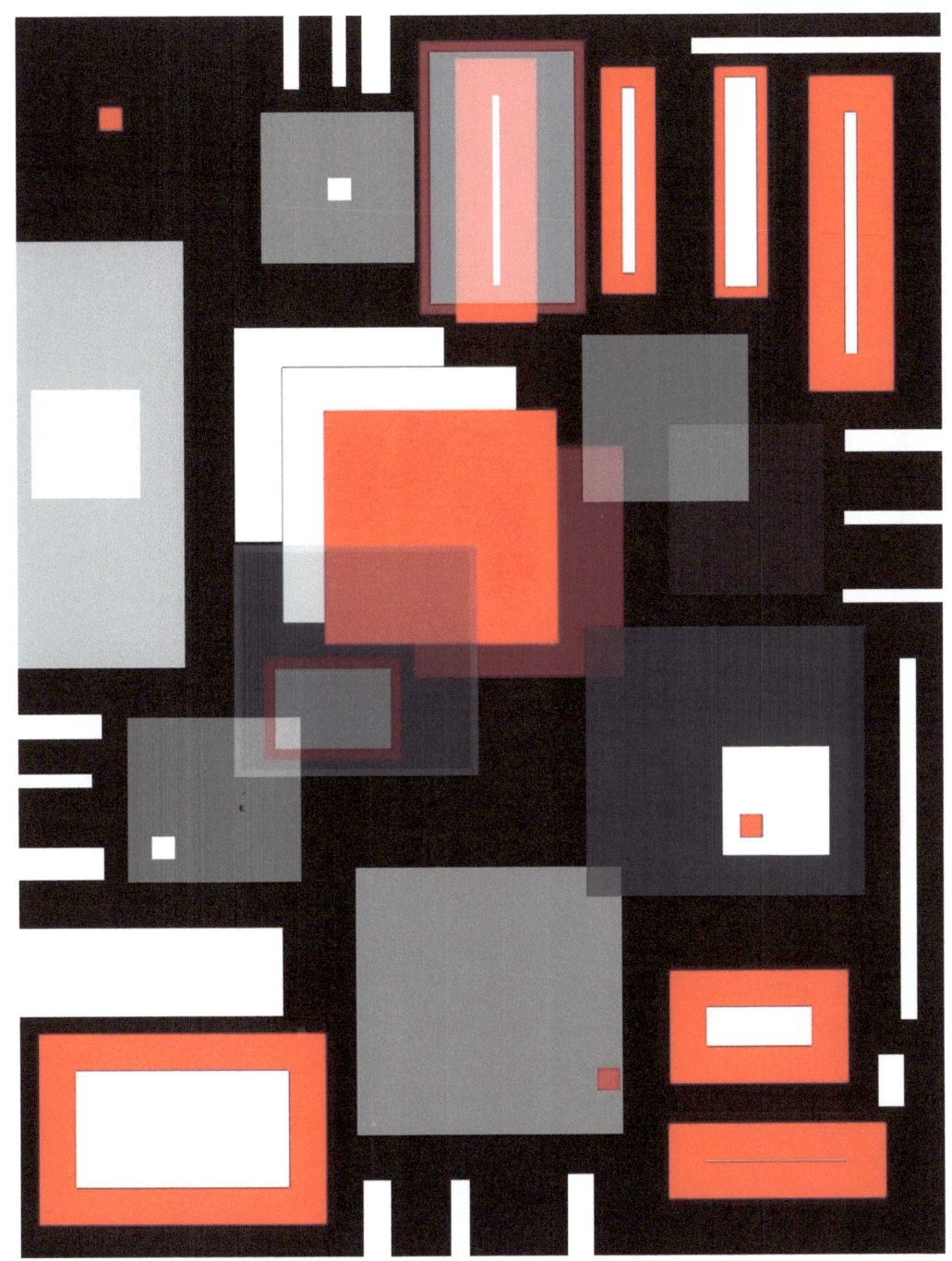

# TITLES

**PAGE:**

1. Logo for Eye Demon Studios.
2. Cobwebs In A Black Hole Squared Reflecting Moonlight.
3. Fractured Metaphor.
4. Cloudy Day Through A Skylight In A Darkened Room.
5. Squares Growing In A Window Planter Outside My Studio Window On A Sunny Day.
6. Mars Eclipsing The Moon In An Alternate Galaxy.
7. Pregnant Square With Twin Offspring.
8. The Opposite Of A Black Period With No Sentence.
9. Some Mutated Squares Don't Have Bellybuttons.
10. Nine Black Squares Chosen At Random.
11. Pair Of Nines
12. Red-light District On A Moonless Night.
13. Crescent With Black Hole.
14. Back Stage At The Grand Theater.
15. Cottage With Black Roof.
16. Flag.
17. 24 Less One.
18. Over The Line.
19. Drip.
20. Imperfection.
21. Third Floor's On Fire!
22. Faded Glory.
23. Maze.
24. The Smoker.
25. Would You Look At That!
26. Christmas Tree.
27. Look! The New Girl's A Ginger.
28. Cemetery Of Nameless Souls.
29. Robo-Traffic Cop With Caution Flare On a Dark Road At Night.
30. Directional Conflict Among Strangers In A Red Van.
31. Robo-Traffic Cop In the Blue Zone.
32. Descension.
33. Sexless.
34. Married With Children.
35. Motherboard.
36. A Grey Monochrome Painting On A Matching Pin-Striped Wall.
37. Window With Venetian Blind On A Pink Pin-Striped Wall.
38. Standing On The Roof Of My Futuristic House Wearing A Red Cape.
39. E-3

www.ingramcontent.com/pod-product-compliance
Lightning Source LLC
Chambersburg PA
CBHW051103180526
45172CB00002B/751